Be More Drag

Be More Drag

Life hacks and tips from the queens and kings of the catwalk

Brandi Amara Skyy

DOG 'n' BONE

Dedication

To anyone and everyone who has dreamed of being something bigger, bolder, and badder than what we are taught and told we can be.

Published in 2023 by
Dog 'n' Bone Books
An imprint of
Ryland Peters & Small Ltd
20–21 Jockey's Fields
London WC1R 4BW &

341 E 116th St
New York, NY 10029

www.rylandpeters.com

10 9 8 7 6 5 4 3 2 1

Text © Brandi Garcia 2023
Design and illustration ©
Dog 'n' Bone Books 2023
The author's moral rights have
been asserted.

A CIP catalog record for this book is available from the Library of Congress and the British Library.

ISBN: 978-1-912983-68-1

Printed in China

Editor: Caroline West
Designer: Geoff Borin
Illustrator: Camila Gray
Additional illustration: see credits on page 141

Art director: Sally Powell
Creative director: Leslie Harrington
Head of production: Patricia Harrington
Publishing manager: Penny Craig

CONTENTS

SCHOOL IS IN SESSION!

You are about to enter The Drag School of DREAMS, HUNTIES!

This Drag School of Dreams is more than just your run-of-the-mill drag school. This is a full-blown **UNIVERSITY OF A SICK-O-NEEN, DREAM-FULFILLED YOU!**

This little book is all about living **BIG BOLD BODACIOUS DREAMS. AND!** It comes chock full of stories, advice, and quotables from some of the fiercest professors in all the world: drag artists.

So, gather your belongings, throw on your best tipping outfit, and get ready to slay the game of life, *the drag way*. Your dreams never looked so flawless!

Now, let's get this dream slayage started!

NEW STUDENT ORIENTATION

The Curriculum

You've enrolled in the world's most iconic classroom! Now, here's how the *Be More Drag* University gets down:

★ **THE SEMESTERS** are the big picture.

★ **THE LESSONS** are the work.

★ **BE MORE DRAGWERK** is the praxis.

★ **DRAGUATION** is a checklist.

Each of these is a key ingredient in creating the right tincture that will catapult you onto the road to living, fulfilling, and slaying your dreams. Now let's look at them in turn.

THE SEMESTERS

The *Be More Drag* curriculum is broken down into semesters that focus on a key concept, belief, quality, or activity that you need to dive into to live your best, most dream-infused life. Think of each semester as individual themes (like a *RuPaul's Drag Race* challenge) that will guide your time, energy, and attention to the lessons and Dragwerk, which will then become the building blocks to creating your most stunning life!

THE LESSONS

There are three lessons in each of the first six semesters and two in the final one. Each lesson opens with one of your professor's fiercest words of advice to get you into the groove. And the content for that lesson is packed full of stories, advice, and tips to help you move past any hindering beliefs, thoughts, and patterns, and get you one step closer to where you want to be.

Be more DRAGWERK

At the end of the first 17 lessons, you'll find a *Be More Dragwerk* section, which will guide you in an activity to help unlock your most flawless self. Now, this is what non-fierce folx would traditionally call "homework." But the Dragwerk you'll find here is **ANYTHING BUT** conventional.

Each Dragwerk was designed to get your mind, body, and creative juices flowing and taking action. **DO NOT SKIP THESE!** The Dragwerk for each lesson is **FUNDAMENTAL TO DRAGUATING TO THE NEXT SEMESTER**—and, most importantly, to living your dreams.

YOUR *Draguation*

Before you can move on to the next semester, we need to celebrate the fierce AF dream catcher you're becoming. *And* we need to make sure that you've completed all your Dragwerk and are actively living the *Be More Drag* lessons you've been learning.

So as your Head Dragmistrexx, I created a Draguation checklist to be completed at the end of each semester to ensure that you're living up to your fullest, most flawless potential as the Goddexx you are!

But before you hit the commencement stage and we release you into the wild, you'll have one grand-death-drop-finale exam that will test *e-v-e-r-y-t-h-i-n-g* you've learned here at The Drag School of Dreams!

Don't get it twisted! We promise that your final exam will be **THE MOST SICK-O-NEEN** final exam you've **EVA** seen!

We can't wait to see you there!

Be More Drag

SYLLABUS

Instructor: Head Dragmistrexx of Be More Drag and Chair of The Drag School of Dreams, Brandi Amara Skyy

Email: yougotthis@bemoredrag.com

Office Hours: To infinity and beyond fabulousness

Course overview

Students will learn to be their fiercest, most authentically flawless selves, so they can sashay down the runway of their dreams, own the stage, and feel and look damn good doing it!

Required texts

Be More Drag: Feels like a no-brainer, but my goal is to make your Draguation a sure thing, which means taking nothing for granted! This book is now your drag, life, and dream bible!

Course materials and supply list

Every classroom comes with its own list of necessities to help you make the most of your learning. And The Drag School of Dreams is no exception. Below you will find a list of supplies to make your experience that much more seamless and glamorous! The Dreams and Life Slayage Support Pack should include:

★ **YOUR FAVOURITE PENS** Because chasing your dreams should feel and look like fun. Pens are like makeup brushes: the right ones will help you paint your fiercest and most unique mug. And the right pens will help you craft, plan, and paint your way to a sickening life. We highly recommend the glitter variety!

★ **A JOURNAL** Not just **ANY** journal. A journal whose cover, color, and the texture of the pages make your drag heart sing! If you can't find the right one that screams **"BITCH! I'M FABULOUS!"** then make one. Collage a boring, old, black-and-white composition notebook and BAM! You've got the fabulousness you seek at your fingertips!

★ **AN "I'LL DO WHATEVER IT TAKES" ATTITUDE**

Because you're going to need it. But more than need—you're going to have to commit to living your dreams. Every. Single. Day. Because there will be ebbs and flows, peaks and valleys, and some days/weeks/months shit is going to get hard. **But you've already done hard things**. The goal is to remember what exactly you did! (More on that in Lesson #3.)

★ **AND FINALLY**, and most importantly, your attention. Your awareness. Your presence. Because your dreams demand nothing less from you.

I, as your Head Dragmistrexx, expect nothing less of you. And your drag professors will help you command this kind of focus, presence, and staying power, and draw the possibility out of you.

We're all in this together! And we got you, boo!

How to use this book

This book was consciously written to be many things, at the exact moment you need them. It was first and foremost created to be the fiercest, most fun, and most fabulous school (and book!) on the planet. One that's not just pretty and dope to look at, but was also really and truly born to change your life. To help you live your dreams—and be flawless while enjoying the journey. While that is its core mission, *Be More Drag is also...*

★ A manual on the mindset, attitudes, beliefs, and actions you need to take to manifest your dreams.

★ A roadmap of folxs who have done it—particularly the kings, queens, and royal everythings who made their life their art and are still making art of their lives.

★ A course that can be taken and read in a linear line, from start to finish, pausing to do the Dragwerk and implementing the skills of each lesson into your life in real time.

★ An interactive, multifaceted, intergalactic, choose-your-own internet adventure! This is more than just your average book or course... *Be More Drag* is a multidimensional, multi-platform experience. The words don't just live on the page; they live in companion (and some Easter egg secret) places, videos, podcasts, and more!

★ And finally, a reference book for the lifelong journey of living your dreams. Because dreams (like our lives) are cyclical and there will always be moments when you'll need more courage, or a gentle reminder to believe in your dreams, and/or tools to tap back into your personal power. Whenever you find yourself in need of those things or a reminder of who, what, when, where, and why it is worth working toward your dreams, return to the semester or lessons you found most helpful and re-immerse yourself in their guidance. As I always say to my flients (friends + clients) and students:

**YOU CAN ALWAYS
GO DEEPER.**

And in truth, that's the heart, the *el corazon*, of this little book of big dreams. Finding, creating, and paving ways always to go deeper into ourselves, our dreams, our magic, and our power to make the impossible, possible.

A FINAL NOTE FROM YOUR HEAD DRAGMISTREXX

Your dreams are not impossible.[1]

Let me say this again for all the kids at the back of the room

YOUR DREAMS ARE NOT IMPOSSIBLE.

How do I know that? Because my life is a testament to making the impossible, possible. This book, this universe-ity that you are holding in your hands is a testament to what happens when your dreams meet action.

 So, my dahlings...

Welcome, new class of whatever year you are reading this, to a school, book, and journey like no other!

This book really is a roadmap, an atlas of how I—and so many other amazing drag artists—have managed to live our dreams despite what the naysayers, haters, laws, oppressors, society, and/or culture say. And despite the

[1] If you're loving the idea of "Your Dreams Are Not Impossible," I've got something uber-special for you in the Real-Life Resources section at the back of the book. (No peeking!)

Brandi Amara Skyy

disempowering and harsh things we say to ourselves. Our own internal voices can be our most spiteful, hurtful, and painful oppressors.

But you're about to embark on a journey to turn all that bullshit on its head. To flawlessly write your way into a new story. A story where living your dreams, feeling good, and being your own damn cheerleader is the norm, not the exception.

You can do this.

I—and every other drag artist in this book and out in life—believe in you! Welcome to the fold, youngling!

Now let's get **SICKENING!**

PREREQUISITE

Reading is fundamental—and so is your commitment to *Be More Drag*.

You might be thinking "Be More Drag" sounds good, **BUT...** *what exactly does it mean?*

Here's the tea: When it comes to living your dreams, there is no better model for what that looks like than the world of drag. Drag kings and queens are fierce, opulent, and grand. They appear, from the outside, always to **KNOW** (not just think!) that they are the most sickening person in the room and to brush off the shade of haters and trolls as quickly and easily as they dust off the excess banana powder from their cheekbones when they're done baking.

This book is a course from The Drag School of Dreams. It bottles up all that magic and redirects it in a way that illuminates the actions, beliefs, and fierceness we need to embody to make the most of our life by living out our dreams. At its core and in essence, "Be More Drag" means:

★ Being more **FIERCE, WILD, AND COURAGEOUS** in your life.

★ Embracing your **UNIQUENESS** and what makes you **DIFFERENT**.

★ Learning how to **OWN THE STAGE**—whatever stage you're at or find yourself on. (Spoiler alert: the world's biggest stage is the one called *your life!*)

★ Making **LOUD, AUDACIOUS, AWE-INSPIRING ART** out of your life.

★ Creating yourself in your **OWN IMAGE**.

★ And, most importantly, it means having **MORE FUN**!

Alright! Orientation over! Let the first semester *snap* begin!

BELIEVING IN YOUR DREAMS: LESSONS FROM THE CALL

You hear that, qween? It's your dreams calling. They've been calling—sometimes SCREAMING at—you for a long time.

And if your dreams are anything like mine, they've been ready for a kiki since you sashayed out of the womb. And maybe for a while, you listened. Maybe you even followed and acted on them.

But somewhere along the way—perhaps it was the pressures and stressors of adulting, or because you felt different, or didn't feel supported, or any number of things—you forgot the magic and ferocity you were born with.

You forgot *gasp* *your dreams*. And just how achievable they are. But it's time to remember, hunties! So, grab your most epic sunnies, as it's about to get real bright with your light up in here, okurrr?

HUNGER

ME: What is your advice to someone who is wanting more from and in their life?

COCO BARDOT: Take it. Well, with consent, of course. You only have one life and tomorrow isn't guaranteed, so you might as well try to achieve as much as you can while you can. (PC1)

Let's kick off our series of lessons in the exact place where every good story, every great drag artist, and every grand and fabulous life adventure begins—with that pang in your gut that screams:

I AM MEANT FOR SOMETHING MOOOOORE!

And child...

YES ★ YOU ★ ARE!

It's time for you to claim what's on the other side of that "more"! That reclamation, that desire, your daring to dream, and your commitment to taking action is why you are here—reading this book, on the planet, in the world.

That hunger is what will lead you to fulfill your life purpose, what will propel you toward living your best life, and what will lead you to the land of all your dreams fulfilled.

That hunger for more brought you here to our Drag School of Dreams and to the precipice of serving up your greatness, art, and heart to all of us!

And it's this insatiable hunger for more that will keep fueling you and firing off on all cylinders until you absolutely get to where you want to go.

But it all starts here. It all starts by saying a full-bodied **YES** to that hunger! And that **YES** begins now.

DragVICE

AARON DAVIS *(my first introduction to drag and the first queen to take me under her wing)*

"Listen to anyone willing to give you advice, then always go with your gut, even if no one else gets it. The ability to shine comes from within. It's never a reflection of another's light." (PC2)

Can we get an AMEN up in here?!

AQUARIA

"My mantra is 'Don't dream it, be it.' Is that corny? Put your mind to something and if it never happens, boohoo, life sucks. But if something does happen, then you got it! So don't dream it, be it, but work hard for it." (IR1)

And that's exactly what we are going to show you how to do throughout this course!

Be more DRAGWERK

So, let's get down to the business of finding out what this hunger for "more out of life" really is! For me, "more out of life" meant:

★ Not just one, but multiple avenues and modalities to express myself.

★ Making history, busting through all kinds of ceilings, and paving new ways.

★ Being a drag queen no matter what.

So, what does "more" mean *for you*? What *more* do *you* want in your life? In other words, what big, bold, audacious dreams do you have? Grab your journal. It's time to get to werk, hunty!

Journal Prompt #1:
Define your "more." What does that "more" look and feel like?

Does it feel like mile-long false eyelashes or picking up a pen and writing a poem? Does it feel like a stage, a microphone, or some other tool or platform to express yourself? Does it feel like a dream career, a more aligned job?

Journal Prompt #2:
What big, bold dreams do you have?

Write them aaaaall out. Everything. Nothing is too big, too small, or too impossible. If you dream it or desire it, write it down!

And then claim it! As you speak it, so it shall be! Because here's the *Be More Dragwerk* tea: Knowing what your "more out of life" and your big, bold dreams are—whether it's drag, making money off your art, or becoming an influencer, **WHATEVER**—naming and claiming these things *for yourself first* is **EVERYTHING** and will go a long way in helping you make that "more" a reality as you move through this course.

LESSON 2

FAITH

"No one is going to cheer for you harder than you have to cheer for yourself!"

Bob the Drag Queen [IR2]

What's that I hear you saying? You have a hard time believing in yourself, much less your dreams?!?

Well, I'm about to let you in on the biggest secret in the business. Hold on to your lacefront because this tea is about to bust through **ALL THE SEAMS**... You ready for your first Drag Secret?

Drag Secret #1:
WE ALL DO. We all—drag artists, creatives, magic makers, anyone you admire—every single one of us has had a hard time believing in ourselves, in our skills, talents, and ability to make our dreams a reality. And you want to know the only difference between us and you?

WE MADE THE CHOICE TO MOVE FORWARD *DESPITE* **OUR DISBELIEF.**

Because ultimately, faith is a choice we can choose (or not choose) to make for ourselves. Again, *faith is a* **CHOICE** *we can choose (or not choose) to make for ourselves.*

Every time a drag artist says "yes" to competing in a pageant, they are making the choice to have faith in their ability, skill, and talent to win. As drag artists, every time we paint our face, show up to tip at a club, or step on stage, we are betting on ourselves. And you can do this too.

LET'S GO!

Drag VICE

PEPPERMINT

"Despite everything you hear from other people, everything you feel on the inside is right. Don't wait to express it." [IR3]

A big part of faith is learning how to silence the outside noise and to trust yourself. Return to Peppermint's words whenever you need a boost!

COURTNEY ACT

"The only thing wrong with me was that I thought there was something wrong with me." [IR4]

'Nuff said.

TOMMIE ROSS

"As simple as this might sound or actually might be, the fact is EVERYONE is worthy. And also, the mere fact that the creative seed has been planted inside of you is more than enough. So, stepping out in faith to make your dreams a reality is justified." [PC3]

Meaning, YOU GOT THIS! And it's time to CHOOSE faith!

Be more DRAGWERK

Your Dragwerk for today is a tiny action that can have a HUGE impact:

BET ON YOURSELF

How can you bet on yourself today? What's one thing you can do or believe to get you that much closer to living out your dreams? Whatever your answer is to the question, take *that* action.

Extra credit work (for gold star Dragwerk status!). Grab your journal and answer the following prompts:

★ When have you already bet on yourself in the past?

★ How can you make betting on yourself (ie having and showing faith in yourself, your choices, your wishes, your desires) a part of your everyday life?

LEAP

"Obviously, you should always play to your strengths and know your wheelhouse and know what you are good at... But yeah, I think it's all about taking a risk. I really do. You gotta put yourself out there, you gotta kind of, just go balls to the wall!"

Brooke Lynn Hytes [(IR5)]

Storytime! I remember to **THE T!** the *exact* moment I made my first leap into bona fide drag queen. It was 2010 and our whole **SOMETHING FABULOUS!!!** performance gang had gotten together at a friend's pool to celebrate Labor Day weekend. I was in the pool with my tequila and pineapple when I asked my drag mother and best friend, Jenna Skyy, if she would represent the Resource Center (the LGBTQIA+ and HIV/AIDS non-profit place where I worked at the time) in the Miss LifeWalk Charity Pageant.

To my surprise, she said, "No." And after a moment of being taken aback by her answer, it was like some force outside of me came down and through me to guide my mouth open and power my vocal cords to say, "I'll do it." Those three words, spoken out loud to a group of friends who I knew would hold me to it, were my first and most important leap.

And it was a **HUUUUGE** leap because there were no AFAB drag performers in Dallas at the time. I would be the first. And I had absolutely *no fucking idea* how it was going to turn out.

But despite my fear of the unknown, I followed up my words with action and I competed.

How did I manage to overcome my fear and all the naysayers giggling at me when I told them I was going to drag?

Faith. (Yep, we're back at Lesson #2!)

Because the Leap—and our ability *to* leap—is intricately and intrinsically tied to our faith in our ability to survive and to be preserved *no matter* what.

And this kind of radical faith in ourselves lays the tarmac for us to take off in our dreams and can only be sourced from one place: our own lives. From our lived truth of having *already* done hard things—coming out, surviving being bullied, fighting for our rights for legal partnership. Prancing down the street as our hyper-excessive and flamboyant selves despite the disapproving stares, signs of hatred, and bigoted slurs being thrown at us.

That's *our* story of faith, perseverance, and bravery.

But you have stories of radical faith in yourself and who you are too. And in the Dragwerk in this semester, you're going to find them.

*Drag*VICE

KYLEE O'HARA FATALE *(on the first time she leapt and did drag at a local talent night)*

"I signed up and it was almost like jumping out of a plane. Picture this: you're standing there, you're looking down, you're 20,000 feet in the air, you know you want and have to jump out of this plane, but you're working your way up to it. And then you finally actually jump. That's what it felt like when I signed my name on the talent sheet and waited for them to call my number to compete. It was literally like jumping out of a plane. And then at that moment, I kind of lost myself. It was like I was on autopilot. It suddenly felt like I was doing this—and I had been doing this—for a minute." [PC1]

You've got to trust your gut, babe! You've got to use your hunger as fuel, your faith as momentum, and your intuition as trust, and LEAP. Every single drag queen, king, or royal in-between that you admire at some point made the courageous leap into the unknown. You can do it too.

Be more DRAGWERK

So, you might not have come out or competed in a drag pageant, but somewhere in your life story, there are testaments to your ability to do hard things. And today? Today we are going to round up all that proof and create one of the most powerful lists **OF YOUR LIFE!** I call this your **"I SLAY"** list.

What is an **"I SLAY"** list, you ask? Well, it's a list of all the leaps and/or the hard/impossible things *you've already done* all put down on paper. Because the point is to remember all the things on your list—**ESPECIALLY** in those moments when you need some encouragement to make your next big leap into your dreams!

Set aside anywhere from 30 minutes to an hour for this Dragwerk. Here's how it all goes down:

★ Throw on some Beyoncé, Lady Gaga, Lizzo, or RuPaul's "Sissy That Walk" to inspire you.

★ Open your journal and at the top of a new page write this question: "What hard things have I *already* done?"

Write down any and all things that come into your mind in answer to this question. Perhaps: *Graduated high school*

(or got your GED)? Stood up to a bully? Left your day job to drag? Quit smoking cold turkey? Left an abusive relationship? Moved to another city/state/country? All of it counts. Nothing is too big or too small. Get it all down. (Also, fierce side note: those are all hard things I've done personally!)

★ When you've exhausted your life looking for examples, stop. Take a moment to breathe in your fierceness and then open a fresh document on your computer and type **"I SLAY"** at the top. Then spend the next few minutes typing out *everything* you wrote down. And then print it out.

★ Now put the list in a place where you know you'll see it every day! You could put it on your fridge, on your mirror in the bathroom, or make it your phone wallpaper—or all three! Use your imagination and trust yourself to know *exactly* where it needs to go so you can see it.

Your **"I SLAY"** list is proof that you've already leapt before. And the dreams you're now chasing? They will soon be on your **"I SLAY"** list too!

YAAAAAAS QWEEN!

YOUR *Draguation*

Bring out the posse and let's pop some bottles in celebration because... You *have just* made it through your FIRST semester in The Drag School of Dreams! And you are **SLAYING!** But before you can move on, make sure to check off all the Dragwerk you've completed so far. Let's go!

★ **Course Materials and Supplies:** You've gathered together all the sickening supplies you'll need.

★ **Lesson #1:** You've journaled on the two prompts—"more out of life" and "big bold dreams."

 ★ **Lesson #2:** You've taken your "I bet on myself" action.

 ★ **Lesson #3:** You've created your "I Slay" list.

Extra credit:

★ You journaled about the times when you have already bet on yourself and how you will continue to do so (Lesson #2).

YAS HUNTIES!! YOU DID THAT ISH!

Now keep the momentum rolling and sashay your way into Semester 2!

SEMESTER 2

NOW WHAT?: LESSONS FROM THE JUMP

You've named your dream. You've made the leap. So, you might be thinking, this is great! But... now what? What do we actually do to keep our momentum going?

Well, my little pretties, this semester we're going **ALL** in, not just on how to start, but also how *to keep* the flawlessness flowing and going. Hold on to your lashes and stashes, childrens! Your dream life is about to get lit!

GETTING STARTED

"I constantly remind myself that I am human. That I am enough, and as long as I always give 100% of myself, that will always be enough. My advice is, when in doubt, stop. Take a look at yourself in the mirror and remind yourself of who you are and why you're here."

Layla LaRue [PC1]

The first time we sit down to paint our face, or draw on paper the vision we have in our head, or put together a performance, or style a wig, or write our life story, or chase after our dreams, there's always a moment of panic. A moment of pure chaos. A moment when we're like, "What the F*** did I just get myself into?!?!?"

And that panic—and whether we let it get the better of us—can make or break our start. That panic then turns into an overwhelming feeling of not knowing where or how to begin. This makes us start searching for and consuming an onslaught of information, tools, how-to videos, and opinions that seem to

swarm at us all at the same time. Which then leads us to a creative and dream-chasing stalemate.

Today, we are going to flip that tired old script on its gutted head! We are going to remind ourselves that this place of gunky, crunchy, and murky beginnings is where all things are possible. And it's where all the magic and the seeds of creative potential live.

From this vat of "now what?" chaos, a whole new persona or poem, song, book, dance, brewery—whatever your dream is—can be born.

All you gotta do is *break through*.

And the **MOST** important thing you can do when you find yourself in this space is to keep going. Keep pushing. And take comfort in knowing that everything you are feeling right now, every single drag artist, pop icon, or movie star you admire has felt before, when they found themselves in exactly the same chaotic WTF spot you are moving through now.

They all got past it—and so can you. Because your true power comes from turning the muck of what you're experiencing right now into art, into magic, into your dreams, into whatever the F*** you want it to be!

Drag VICE

KYLEE O'HARA FATALE

"I was with all these people who had been in the game for a while and had their stuff together as far as their looks, their jewelry, their costumes. And I was terrified. Because I was gonna be next to them. And I knew I was gonna be ugly because we all are [our first time], but I ultimately had to combat that.

My success always relates back to my sense of 'false confidence,' as I say. Me telling myself, 'OKAY! WELL, YOU'RE EVERYTHING!' to hide and shut down all the background noise of me being terrified." [PC1]

At this point in your dream game, the best thing you can do is shut down the noise and keep moving forward. Use Kylee's "False Confidence" tip whenever you need a push to help you get over the hump of being stuck.

Be more DRAGWERK

Bust out your "I Slay" list (see pages 38—39). More than likely, each of the achievements you wrote down was pre-empted by a moment (or moments) of chaos, of not knowing, of guck and muck before you made it through to the other side.

So, here's what I invite you to do. Choose three things from your list, grab your journal, and answer the following questions:

★ What was happening *before* you achieved each thing?

★ What did you do, say, believe, or welcome into your life to help you break through the guck and muck, and slay anyway?

★ What things (if any) helped you gain clarity?

Whenever you start to feel overwhelmed, stuck, or unsure of where to start, use your answers as a blueprint for how you can break through the muck to get where you are determined to go!

INSPIRATION AND APPRENTICESHIP

"No matter how close you get to achieving your goals, never stop learning. There is something you can learn from everyone. Some way they can inspire you."

Ivory Onyx [PC2]

Here's Drag Secret #2:
To drag artists, EVERYTHING—and I mean everything—is inspiration. When it comes to inspiration it's not just music, pop stars, or movie icons that inspire us—it's literally anything we like, see, or love.

Pabst beer? Yep

Our own tattoos? Yep!

Storybook characters? Yep

Sickening, right?! And when it comes to you and your dreams, you've got to adopt this "it's all inspiration" attitude too. It's honestly **THE MOST** revolutionary thing you can do.

Because when we say "yes" to everything as a potential source of inspiration, **THE WAY** we engage and interact with all the elements in our life drastically changes—and that in turn can change everything and anything. Inspiration allows us to see:

★ A set of string lights come alive and ask to become part of a costume.

★ The scent of our lipsalve conjuring up a vibe for a new performance.

★ A song becoming a gateway to another world.

★ Or an everyday vodka company's name (Skyy Vodka) giving birth to an entire drag haus, legacy, and drag dreams.

Inspiration is ALL around us. **THE ONLY QUESTION IS: "WHAT DO *YOU* SEE?"**

Shift your perspective; change your life. It really is that fantastically simple!

But/and/also, when inspiration fails to find you, that's when you have to go **SNATCH IT UP, HUNTY!**

And the best way you can do that is to seek out folxs who have already done what you dream of doing and become apprenticed to them—in any way, shape, or form you can.

Apprenticeship—having mentors and role models—is as **ESSENTIAL AS READING**.

Because being surrounded by folxs who have and are living their dreams is exactly how you will get through the times when it all feels hard, draining, impossible, and everything BUT inspirational.

And there will be a lot of that.

TRUST.

Drag VICE

BRANDI AMARA SKYY

"When you are just starting out, I highly recommend having at least one or two *accessible* mentors, meaning mentors that live in your area who you can call and visit... If you are choosing mentors who are a little more unreachable, the best way to get their guidance is to find their body of work and consume it. Did they write a book? *Read it!* Are they on Instagram? *Follow them*. Star in a movie or television series? *Watch it!* Do they have a blog? *Read it*.

Soak up everything and anything they put out. And then figure out ways you can tie everything you learned from them back to you. How can you take what you love about them and make it your own?" (PC2)

JESSICA J'ADORE

"Listen... if you figure this out, reach out and let ME know! Currently, I stay motivated by learning new skills and really honing old skills." (PC1)

Got some advice for your fellow Drag School of Dreams classmates AND Jessica? Share on Instagram using #bemoredrag!

Be more DRAGWERK

Create an inspiration notebook. What's an inspiration notebook, I hear your ask? It's a separate journal or notebook that you will fill with all the things, quotes, stories, people, colors, creations, textures, flavors, literally **ANYTHING** and **EVERYTHING** that inspires you.

Keep filling up your inspiration notebook as you move through the remaining semesters. You could write down passages from this book that you love, your favorite advice, and any **AH HA** moments you have. The *skyy* is the limit!

And whenever you find yourself in need of a bolt of inspiration, a reminder of magic, or something to put a smile on your face when the going gets tough, you can pull out this notebook, turn to any page, and get back into your flawless inspirational groove.

NOW, GET TO WERK!

LESSON 6

DON'T QUIT. PERIOD

"It's okay to make mistakes. It's okay to fall down. Get up, look sickening, and Make Them Eat It!"

Latrice Royale [(IR7)]

★ ★ *This is the most important thing you can do!* ★ ★ Thorgy Thor auditioned **EIGHT** years in a row before making it on to Season 8 of *RuPaul's Drag Race*. I lost the first two pageants I ever competed in. And there are so many more examples of folxs who persisted despite impossible odds—and won!

UGH! I know! *insert massive eyeroll* I hear you say. But you know why we have to keep saying it again and again? **BECAUSE THE CHILDREN NEVER LISTEN!!** Every baby queen and king, or newbie to any art form, or first-time dream chaser, we think we know **EVERYTHING**. But the tea is: **WE DON'T**.

So many of us give up right before we win the pageant, get on the show, pass the test, get a record deal, or live out our dreams. Sure, we all **KNOW** not to give up. But all of us at some point (myself included) don't *act* on that knowledge. But here's where you get to prove me—and everyone else—wrong.

KEEP GOING. YOU GOT THIS!

Drag VICE

RUPAUL

"If you have goals and the stick-with-it-ness to make things happen, people will feel threatened by you, especially if your goals don't include them. They believe that if you take a piece of pie, then that leaves less pie for them. Seeing you follow your dreams leaves them realizing that they're not following theirs. In truth, there is unlimited pie for everyone!" (IR8)

Push on anyway. They will either get on your bandwagon or fall to the wayside. Regardless of what they choose to do, DON'T STOP. Keep going. And stay slaying!

JENNA SKYY

"Fear has a lot of different masks. Sometimes it's fear, sometimes it's doubt, sometimes it's panic or confusion. It's lots of different things. If [things] don't work out or go as planned, those are the things that we get to examine and try again or redirect.

[But] never *in the moment* of fear and panic or anger or discouragement should you be making those choices. It's

no different to going grocery shopping when you're hungry. When you're hungry is the wrong time to go to the grocery store because you will make the worst choices at that moment. And it's the same thing with fear and panic.

If you try to overanalyze, and counter what's giving you fear or insecurity in those moments, sometimes you may not be making the most sound choices. And so, push through them and then revisit." [PC1]

In other words, don't make the choice to quit while you're in the thick of your wild emotions. Push through whatever you're doing. Then evaluate. Redirect. Try something different; just don't quit!

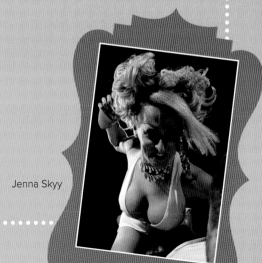

Jenna Skyy

Be more DRAGWERK

Your Dragwerk for this lesson is to create an **"I WILL NOT GIVE UP"** survival pack that you will fill with an arsenal of goodies, advice, stories, this book, other books, and quotes which are at the ready to come to your aid whenever you feel like giving up. Here are a few things that are in mine:

★ *The War of Art* by Steven Pressfield (I turned to this book many times as I wrote this one)

★ My favorite flavors of tea

★ The Latrice Royale quote that opened up this lesson

★ Eos lipsalve

★ Spotify

★ My wife's and my rescue pup June (because sometimes what you really need are doggy kisses!)

There are no rules. Fill your survival pack with whatever makes you feel invincible. And then use it to slay your way through any "I want to quit" thoughts!

YOUR *Draguation*

Bust out the dance moves because we are about to break it down! You survived one of the toughest semesters and the fact that you made it to this draguation is proof of just how flawless you are.

Remember that. Remember that win, lose, draw, or replay, **YOU** are **SLAYING** your dreams. Now, check off everything you've completed:

★ **Lesson #4:** You've dived deeper into your "I Slay" List using this lesson as your guide.

★ **Lesson #5:** You started (and added a few things to) your Inspiration Notebook.

★ **Lesson #6:** You've started to gather things for your "I WILL NOT GIVE UP" Survival Pack.

You're now ready to strut your stuff into Semester 3!

WHO ARE YOU GONNA BE?: LESSONS FROM THE PERSONA

Alright, hunties, listen up! This semester might just be THE most important set of lessons in the entirety of The Drag School of Dreams because it all centers and focuses on your favorite subject... YOU.

And how you, through *Being More Drag*, can really begin to craft yourself into who you need to be, not just to make your dreams come true, but to live an authentic, expressive, expansive, and **SICK-O-NEEN** life. That is what all of us want for you! But here's a little pre-gaming tea:

Your dreams, your life, and living both to the fullest *always* begins or ends with you.

So, let's take this semester to transform you into the most sickening **YOU** that you can be!

Let the fierce games **BEGIN**!

THE PERSONA OR CHARACTER

"Always remember you are your best self, never try to be a copy of anyone else. Continue to seek ways to improve and stay unique. Take your craft seriously and other people will sense that... find yourself, learn yourself, respect yourself, and always present your very BEST self."

The Legendary Tommie Ross [PC2]

If you want to live the life of your dreams, **YOU GOT** to decide who you want to be. And then you have to set about creating it.

Because here's Drag Secret #3:
You can be whoever the F*** you want to be. You don't need permission. You don't need to wait to be sickening until you've made some drastic change, moved to a new city, published your first book, or it's your birthday, a new year, or Mercury is out of retrograde. None of that matters!

You can be flawless, *right now*, by simply choosing to be so—and then taking actions that help foster your most fearless self into being.

This whole book and Drag School of Dreams course are about dreaming and living **BIG**. Being **LOUD**. Making a scene and leaving a mark on life by living it up **FULLY**.

Go as wild and excessive as you want. There are **NO RULES** except for the ones you impose on yourself.

We queens, kings, and royal everythings, **CREATE** ourselves into being. And so can you. Here's some advice on how.

Drag VICE

RICHARD D. CURTIN (on how he created one of his many drag characters, Edna Jean Robinson)

"I drove around Ardmore, Oklahoma, and figured out where she lived, where she worked, where she went to high school, and where her family lived. And I wrote all of that stuff down.

She worked at Miller's Dairy Freeze on the weekends. Miller's Dairy freeze was a little ice-cream store in the downtown area of Ardmore and Edna made the foot-long chili dogs. I gave her a life. I gave her a reason to live, a WHY she was living, and how she lived. I even gave her a little bit of a family background, so that when I went to this party and I interacted with people, I had a story to tell and I knew what that story was." (PC1)

There is soooo much to unpack here. But the biggest takeaway is: create your own backstory for the person you need to be in order to achieve your dreams. (And this is REALLY going to come in handy for your next Dragwerk!)

JESSICA J'ADORE

"There's a drag persona inside everyone. It's usually the piece of you that hides away from others. Listen to that part of you and go with it!" (PC1)

Which is EXACTLY what we're gonna do!

Be more DRAGWERK

Create a drag persona! This Dragwerk is in three parts, as follows:

Part I: Write in Your Journal

Grab your journal and ask yourself these questions:

★ Who do I need to be to make my dreams a reality?

★ What do I have to believe about myself?

★ What do I have to do? Think? Feel? Experience?

Really dig into all the characteristics of this person you need to be. Go back and read Edna Jean Robinson's advice. Get a really *clear* picture of *who* this person is.

Part II: Give Yourself a Drag Name

Yep! Like a bona fide drag name. It can be whatever you want it to be. But this step is SO IMPORTANT! Because what you are really doing when you give yourself a drag name is creating a new space that you can grow and expand into. You get to fill out

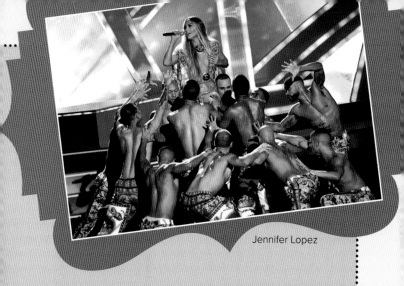

Jennifer Lopez

this new name with all the bits, pieces, flavors, and other goodness you journaled about in Part I.

Remember, it's not just drag artists who create stage personas—Lady Gaga, Beyoncé as Sasha Fierce, Jennifer Lopez as JLO, and even writers have various pen names. This tool is accessible for you too!

PART III: Live Your Name

Here's the long game part of this Dragwerk. Spend the rest of your time in The Drag School of Dreams really harnessing, diving into, and *becoming* who your drag persona/character is!

YOUR SIGNATURE DRAG MUG

"Ugliness is what excites me. What people mean by beauty is often very conservative. For me, it's all about self-exaggerating and embracing things about myself that I'm uncomfortable with... I think I heard John Waters once say, 'If you have a hunchback, don't disguise it, throw glitter on it!' Highlight the things that make you different from other people."

Sasha Velour [IR9]

The first, and perhaps most important, piece of advice I got when I started out in drag was:

"It will take some time, but you'll find your face."

Those words were spoken to me by Asia O'Hara, a long-time friend and someone I would sit and watch paint weekly for hours

on end. Asia had clearly found her face—as most professional drag artists do.

Because finding one's signature drag mug is basically like defining one's own signature brand. And if you want to be something unforgettable, it all starts with what makes you memorable. And the same holds true for you!

What's your signature?

Your signature, that thing that makes you unforgettable, can be *anything*—your look, your motif, your voice, your style, your color palette, your vocal cadence. *Anything.*

Finding what makes you unique and what helps you stand out from the crowd is equivalent to a drag artist finding their signature drag mug.

And here's Drag Secret #4:
A drag mug (or lack thereof) can make or break a drag artist's drag. And not knowing or claiming what makes you special can and will make or break your success.

But here's the other side of that coin: it might take you a while to find it. And that's okay. The goal of this lesson is to get going with discovering it.

And once you find it, you have to **OWN IT**.

Claim it. Live it. Breathe and be it.

As often as possible.

Drag VICE

MISS ANITA MANN

"The most important thing to remember is that we all had to go through the ugly stage to get to the pretty stage." (IR10)

Again, getting to the "pretty" ugly (as Sasha would say) or signature stage is going to take some trial and error. Let go and let GAWD and GET INTO the process!

MAY MAY GRAVES (when asked about finding her signature drag mug and drag style)

"You don't know who you're going to be until you walk out on stage, and then whoever it is, takes over. [It's like] there's something inside you that's been growing and it's been incubating for so long—and it's all this trauma, all this life experience, and it's been waiting to come out. And so, it comes out through your art, but you don't know what it is because it's been so dormant for so long.

There's a difference between a younger drag queen and a more seasoned drag queen, and that is the fact that whenever a younger drag queen learns makeup,

they learn someone else's makeup on their face, and so they don't look 100% like themselves.

But after doing it for so long, *it does morph* into yourself. And you start to learn more about yourself by starting to do the drag that you'd like to see. And then as *that* morphs, in this meditative state, whenever you're putting on your makeup, you start wanting to try new things that come from that dormant place where your drag started. And that dormant place starts telling you, '*But what if you did this? And what if you did this?*'

And it's a matter of following what that almost inner child wants to do and learning to listen to that voice while also listening to the advice of people who have been successful—and learning why they were successful. And it's just a matter of marrying the two ideas." (PC1)

In other words, for all of us dream chasers, our X-Factor, our signature, what makes us unique is ALREADY in us. Right now. And in our next Dragwerk we are going to see if we can help jump-start the process shared by May May.

Be more DRAGWERK

Grab your journal and your favorite pen because we are about to swan-dive into some prompts and actions to help us kick off our "What is my X-Factor?" journey. Here are some journal prompts:

★ What makes you unique?

★ How can you amplify what you wrote down above and really claim it?

★ What energy do you bring to the room? And what energy do you leave behind?

★ What is your special blend of magic?

LESSON 9

CONFIDENCE AND CHARISMA

"My confidence comes from deep in my soul. It was fed by Broadway musicals and 90s MTV. Do more of what feeds your soul as often as possible and let it feed your confidence."

Jessica J'Adore [PC1]

Here's Drag Secret #5:
When a queen goes out tipping, THEY WANT TO BE SEEN!

We will show up to the hottest shows and pageants, dressed to the "T" in our most sickening outfits, because we all want the world to know that we **DIDN'T COME TO PLAY!**

And neither should you! Show up fully. Show up ready and roaring to **GO**—regardless of whether you're the main attraction or not. Show up as if you are. Because one day, you will be.

*Drag*VICE

SHEA COULEÉ

"I'm all for ambition, but ambition ain't nothin' without execution." (IR3)

Which means you gotta walk your talk. (More on how to do that in this lesson's Dragwerk.)

JENNA SKYY

"Trying to be the fierce person that you are, you have to really know what it is you're trying to offer and present." (PC1)

This is why Lesson #8 and finding your version of a signature drag mug IS SO IMPORTANT! The more you know who you are and what makes you unique, the more readily you'll be able to channel your inner fierceness!

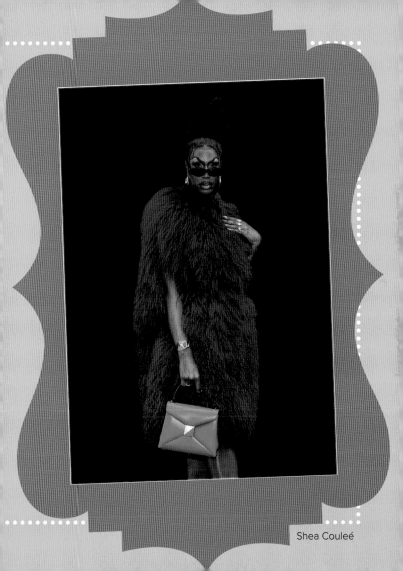

Shea Couleé

Be more DRAGWERK

Show up and **SLAY!** Got invited to a party where someone you've been dying to network with will be? Show up and slay in an outfit extravaganza that makes you feel like royalty!

Heading out to a writer's conference? Show up with your novel in your rhinestone duffle bag, your QR code business cards, and get your mind and 'tude ready to slay the kids!

The goal is to be intentional about how you show up—and what you show up in!

WHAT WOULD *YOUR* DRAG SELF DO?

Answering that one question while you get ready, choose an outfit, and walk out your door and into the room is **GUARANTEED** to help you show up and slay!

YOUR *Draguation*

You are giving us so much life right now! And guess what? You are now **HALFWAY** through your schooling! Take a moment to really let everything you've done and accomplished sink in before moving on to this semester's checklist:

★ **Lesson #7:** You've created a sickening drag persona that will grow with you and your dreams.

★ **Lesson #8:** You journaled about and are committed to knowing what your X-Factor is.

★ **Lesson #9:** You've shown up to and **SLAYED** for at least one event of your choosing.

Bask in the fabulousness of your own glory. And when you're ready, we'll see you in Semester 4!

COURAGE AND BRAVERY: LESSONS FROM ADVERSITY

This semester we're gonna get deep—deep into your courage and bravery, and what that all means for your dreams.

We're also going to touch on all the haters and trolls who will come out of the woodwork as you continue to slay. And give you a boost of encouragement when the path to your dreams leads down the road of heartbreak.

It's all part of the adventure. And one day, it's going to make a beautiful arc in your story.

But today? Today, we're going to show you how to hold your head high, keep your lashes and stashes tight, and read the trolls for filth. It's all about the glow-up this semester.

Now let's get shining!

MARGINS AND ADVERSITY

"People will respond to your authenticity with fear, jealousy, or prejudice, but it's because you have a power that they do not. And when you're grown up, it is that power that will bring you joy and triumph."

Glamrou [IR11]

At some point along the adventure of living your dreams, you might have heard a voice inside you say:

My dream is just not possible for me because I'm...

Indigenous ★ Black ★ Queer ★ A Womxn ★ Disabled ★ Low income ★ Adopted

Or a part of some other marginalized community. But guess what, hunty? Your dreams **ARE** possible, even—and especially—for you.

This belief—that you can do, be, have, create, and experience anything in spite of the multiple oppressions you are facing—is **THE MOST POWERFUL** tool in your dream-life arsenal. Because

that one single belief leads to the most potent and sickening elixir on the planet: agency.

Your personal agency.

And you've already got a taste of how powerful your personal agency is when you said "yes" to your dreams by picking up this book and getting this far in your studies.

And as your "I Slay" list proves, *you've already done* hard things. You've already been sickening. You've already slayed the game. Beaten the odds. Brought down the house. And you will continue to do so.

Because for every self-made excuse we hold on to, or societal/systemic oppression we face, we can always find at least **ONE** person who proves that, yes, *even for us*, even amid our circumstances, our injustices, our intersectional or many '-isms,' our dreams are possible. And by living your dreams, you also get to be part of the proof that you are seeking.

Now, go make some **HISTORY**!

*Drag*VICE

KYLIE SONIQUE LOVE

"It ain't what they call you, it's what you answer to that matters." [IR12]

mic drop We got nothing else to say!

RUPAUL

"It's easy to look at the world and think, this is all so cruel and so mean. It's important to not become bitter from it." [IR13]

And not to let the bastards get you down. And we can do this without bypassing. How? By fully integrating our experiences and alchemizing them into our power, then expressing all of it through our art. This is how we create change. This is how we do what others deem impossible.

THE LADY CHABLIS

"It's like my mother always said, 'Two tears in a bucket, motherfk it.'"** [IR14]

This line was made famous by The Lady Chablis in her 1997 breakout movie, Midnight In the Garden of Good and Evil. People are going to come for you, but you get to decide if you're going to let them in.

COCO BARDOT

"Doing diva drag has certainly been a journey. Generally, folks really liked my drag in the beginning and I didn't receive too much hate. But once I started getting noticed, I started to get pushback.

I remember being immediately told that I had to perform as my opposite gender. I am not masc at all, so it made drag less than fun. I have dealt with micro- and macro-aggressions by all identities. I would be the only Black girl in many shows and be a 'token.'

To this day, I'm unfairly treated because I choose to remain civil to combat shade because of who I am as a performer. I really just had to learn what I wouldn't be ok with, establish boundaries when working in the drag world, and be willing to walk away from things that wouldn't help me progress as a performer." (PC1)

In other words, boundaries—and knowing what yours are— are an important part of the journey and a tool to help you keep going. Take a moment to think about and write down what YOUR boundaries are.

Be more DRAGWERK

Find your proof. This Dragwerk is all about finding proof of someone who has done what you want to do (or something similar) and also shares similar roots and/or marginalizations as you.

Whatever oppression, marginalization, and/or obstacle you are facing, start looking for folxs who proved everyone—all the odds, oppressors, their friends, trolls, parents, etc.—wrong. This might take some time. But its 1,000% worth it!

This person will become your beacon, proof, and blueprint for how to keep sashaying your dreams forward.

LESSON 11

HEARTBREAK

"There were many chapters that were dark. But I was steadfast, and I held tight to the hope for my future... I weathered the storm and, you know, there were days I forgot my galoshes and my raincoat and umbrella, and I was soaking wet. But at the end of the day, I came home; I was blessed and fortunate enough to dry off and put on something warm."

Alyssa Edwards [PC5]

The first two pageants I competed in, I lost. The first ever pageant in which I danced for my drag mother, she lost. And there are so many more stories of heartbreak on the road to success.

Failure is part of success, and success wholeheartedly depends on how you assess failure. Because chances are, if you choose to live your dreams for the long haul, you will experience failure too—if you haven't already. But here's a new cup of tea we want to offer you:

HOW CAN YOU FAIL, FLAWLESSLY?

Meaning, how can you Beyoncé it up and make lemonade out of lemons? How can you use your heartbreak to fuel your dreams *forward*? In other words, what can you glean from the failure and how can you use what you've learned to up-level yourself, your beliefs, and your thinking for the next time.

I have known queens and drag artists who competed in the same pageant for almost a decade and never won. But they are still out there winning their drag because they don't let their failures bring them down. They upped the ante on themselves. Which is exactly what we want you to do.

Beyoncé

Drag VICE

May May Graves (on making art from the muck of life)

"One thing about art is that it's running toward those things that help you learn more about yourself. Because the older you get, the more things start to fall apart in your head about how the world was. And the way to ground in is by going back and taking stock of what you haven't even touched in years, and looking at that and saying, 'This is a part of me. And I'm going to make it beautiful and put some stones on it, nails on it, and I'm going to embrace that part of me and make sure it's in a healthy place.' Because we all have that character, whether we do drag or not.

And that dormant child that's been through so much, we have to kind of parent that inner child in a way. So, some of us do it through drag, some of us do it through painting, or through screaming in a car listening to our favorite song.

It's a matter of not listening to what anybody else has to say about what you should be doing and just understanding what you need and taking stock of that." (PC1)

Be more DRAGWERK

Grab your journal and think back to a time in life when you failed. Once you have that moment in mind, ask the following questions:

★ How did that failure make you feel? And more importantly, what did you do after?

★ What lessons did that failed attempt teach you?

★ How are you going to do things differently on your next go around?

Return to the proof person you found in the previous Dragwerk for Lesson #10 (see page 82). How and where did they fail? What can you learn from how *they* made it through? Do this after every failure, and I promise you, you will only (and always) get more sickening.

LESSON 12

HATERS

"People been talking since the beginning of time. Unless they paying your bills, pay them bitches no mind."

RuPaul [IR6]

CHILD! If there is one infallible truth of life, it's this:

HATERS GONNA HATE, HATE, HATE!

But it's up to us if we're going shake, shake, shake it off, or if we're going to let the peanut gallery interrupt and disrupt our sickening flow.

Haters go by many different names:
Inner saboteur ★ Gremlin ★ Trolls ★ Shit talkers
But their purpose is the same—to dim your shine.

Haters and trolls are part of the game. And they get louder the more authentically, out loud, and proud you live your dreams. But what happens when the hater's voice is coming from inside us?

Here's Drag Secret #6:

We, ourselves, are *always* our own WORST hater. Whatever folks say about us is never as bad as the shit we say to ourselves.

I am 100% my own worst hater. And if you are too, here's the **BEST** advice I can give you:

Do it anyway and **PROVE** yourself wrong. That proof is the *only thing* that's going to, not stop, but at least silence that mental crap chatter long enough for you to find other ways to keep shutting them down.

One of my all-time favorite pieces of advice when it comes to your inner hater is from a different kind of qween—a writing one. Natalie Goldberg in her book *Writing Down the Bones* wrote:

"If you are not afraid of the voices inside you, you will not fear the critics outside you."

Halleloo!

\mathscr{Drag}VICE

JINKX MONSOON

"When you are dealing with people judging what you do, you just have to let it roll off like water off a duck's back." (IR4)

This has by far been one of my go-to phrases whenever the haters try to bring me down. I can literally picture Jinkx Monsoon on the runway with her eyes closed whispering this to herself. Try it! (And if you don't know what I'm referencing, check out the Real-Life Resources at the back of this book!)

SCARLETT BOBO

"Do not—and I repeat—do not take everything so seriously! It may seem like the end of the world, but just have fun! Don't think about it. Do what you do best and ignore everyone else. People will hate on you if you're successful and laugh at you when you're not. It's a lose/lose situation, but only if you allow it. Find your family and your friends. Don't be afraid of succeeding. Be amazing and try new things." (IR15)

So, just "Be amazing." How can we do more than THAT?

Be more DRAGWERK

Pick someone you admire deeply, who you really feel hung the moon and you aspire to be like. (Or you can continue working with the person you picked as your proof in Lesson #10.) Go to their Instagram, TikTok or Facebook, or google their name.

Go to *anyone's* post and read the comments. I guarantee you'll find haters and trolls there too because they are **EVERYWHERE**. And the higher you rise, the more they are going to come for you too. Keep this lesson handy whenever you need to keep them in check!

YOUR *Draguation*

Phew! I don't know about you, but this semester proved to be a bit harder than I expected.

And yet, **HERE YOU ARE!** Snaps for you! And here's the tea:

All the werk you put into this semester? You're *definitely* going to need it for what comes next. But before we press on, let's take a look at all the Dragwerk you've done thus far this semester.

★ Lesson #10: You've found your proof person.

★ Lesson #11: You've journaled about a time you failed and... you've researched some of the failures your proof person has gone through.

★ Lesson #12: You've read the comments and made peace with the fact that there will always be haters and you've chosen to slay on anyway.

Alright, hunties! Time to get beat for the **GAWDS!**

AND... Get ready to shine like the star that you are!

HOW TO BE A STAR: LESSONS FROM THE STAGE

This semester is all about how to find, shine, and share your most twinkling, bright, shooting-star self!

Whether you wish to be a bona fide superstar, a music icon, a drag queen, a Pulitzer prize winner, or something that hasn't ever been done before, they all have their roots right here in this semester.

It all starts with owning, claiming, and then acting like you are a star—because **YOU ARE!**

YOU, my fierce friend, are the **STAR** of your own movie, the movie of your life. And the narrative of this fantabulous story is the one you are writing **NOW** as you chase down your dreams.

This semester is when you make all your fierceness official!

Let's death drop shall we?

KNOW YOURSELF

"Find a piece of yourself that you love and enjoy. Focus on bringing that part of yourself out, so [other] people can enjoy it as well. It will get easier to start loving yourself, shining, and living life without limits."

Layla Larue [PC1]

A key part of knowing yourself so you can shine is knowing your angles and finding your light! Every grand drag artist you know and love knows how to find their light—and use it to live in the spotlight (more on that in the next lesson).

Finding your light is all about knowing your face and finding the right angles for it—how to tilt your chin just so, or where to place that rhinestone, so the light hits it (and you) just right. It's about knowing yourself so well that you understand exactly which way to turn, pose for the camera, or look to be snapped at your most sickening.

How this translates into chasing your dreams and living your best life is that knowing your angles becomes about knowing what tools and resources—stances, poses, brushes, musical notes, and/or words—can help you look and feel good! Being a star is all about how, where, and how brightly you shine the light within you, outside of you. But you have to claim your light first!

Here's Drag Secret #7:
What every unforgettable and legendary drag artist does is take their inner light (which is a combination of their X-Factor, their personality, and their authenticity) and find a way to expose and express it onstage. And they pour all of that into their performance.

It's a drag artist's soul light that makes an unforgettable performance and brings the house down! And that's exactly what you need to do. Find *your* soul light—your inner star—and then do everything you can to get to know and then express it.

That's how you truly **SLAY**.

Drag VICE

WILLOW PILL

"Since the show [*RuPaul's Drag Race*], I've really taken some time to relax and take time for myself, which is hard when everyone's telling you that this is the hot time to strike. As much as I want to do that, I know that I'm not able to do that. I've really had to learn when I just need to protect myself." (IR17)

This is also something that every iconic drag artist knows—when to be onstage and when to take the rest they need away from it. Living your dreams is a beautiful, expansive, dope AF experience. But it can also be extremely draining. Allow yourself the grace of keeping some of your light to help replenish yourself!

RUPAUL

"Know thyself. Know what it is that makes you, you." (IR18)

And then continue to expound and build upon that.

Be more DRAGWERK

What lights you up? What makes your soul, your insides happy? Learning what those things are will go a long way in helping you discover your shine.

Knowing what tools, resources, books, and words ignite a spark in you will help you understand the flavor of your spark.

Remember your inspiration journal? Crack that open and really begin to soak in all the things that inspire you and light you up. Now, close your book and go do **ONE** tiny thing that gets you closer to your dreams.

You feel the difference?

That difference is you taking the time to spark your light before you take action—and that one small ignition changes *everything*. Keep doing this and you will light up everything you touch!

OWN YOUR SPOTLIGHT

"Be the queen (or king!) you already are."

Brandi Amara Skyy [Self]

These words are the beacon of light that I have been sharing with other folxs who dream about doing drag—or dream about a more creative, fierce, and empowered life.

"Be the queen you already are" means that everything you value, admire, and desire in the drag artists and pop stars who you love, you already house and hold in yourself.

"Be the queen you already are" means that you—right now, without fixing, without needing to do *anything*—are enough. **MORE THAN ENOUGH**.

You are fierce and flawless just as you are. And therefore, you are already a queen, king, or royal whatever you dream of being.

So, in this lesson when I say, "Own Your Spotlight," what I mean is:

CLAIM, SPEAK, AND OWN YOUR TRUTH—AND YOUR STORY.

This is the most life-changing advice any of us can give you.

Drag VICE

WILLAM BELLI

"Drag was always looked at as a stepchild, and I wasn't willing to sit at the kid's table anymore, so I took what's mine. You can't depend on other people to give you what you want; you have to take it." [(IR19)]

Beautiful advice on not settling for less than you are worth.

TOMMIE ROSS

"Never get caught up in the applause. Because if you value your worth by what others give, it could have a negative effect on you." [(PC4)]

Your spotlight will not come from others. It can only be sourced from the depths of you!

Be more DRAGWERK

This lesson's Dragwerk is simple. Grab your journal and riff off this journal prompt:

WHO *IS* THE QUEEN (OR KING/ROYAL EVERYTHING) YOU ALREADY ARE?

Once you dig into that, spend the rest of your day really *living* your answer.

SLAY

"Tap into your power to captivate. Your audience will develop great admiration and respect for this ability. This is a powerful ability that is often malnourished. Entice your audience to succumb to your ability to engage and create that magical experience for them!"

Chanel LaMasters [(PC2)]

Translation: Perform your little heart out—regardless of what industry you are in.

The secret to slaying, putting on an unforgettable performance, and bringing the house down is... YOU. And your attitude, commitment, and presence.

But also, and most importantly, your heart. **THAT'S** the secret ingredient. If you put your heart into it—and I don't mean just tip a valve here and there—I mean the **ENTIRETY OF YOUR BUCKING RHINESTONE HEART** into whatever it is you are doing, the

audience, the room, and the world *will* feel it. Slaying is really that complicatedly simple. You own your stage by sharing your heart. Period.

And here's Drag Secret #8: If there isn't a stage already available for what you want to do, MAKE IT. CREATE IT.

That's exactly what the drag kings who started the International Drag King Extravaganza (IDKE) did. No one wanted to book them, so they booked themselves.

And then a group of four AFAB performers within IDKE, who weren't getting the stage time they wanted or deserved, made history with their Bio-Queen Manifesto.[2]

And that's exactly what I did in Dallas.

And that's *exactly* what you're going to have to do if you are doing something that's never been done before. But if you put your heart into it, slayage is a sure thing!

[2] This term is used for historical purposes only, as that's what the original document was called. However, shortly after presenting the manifesto at IDKE, the authors stopped referring to themselves as bio-queens and no longer condone the use of the term—and nor do I.

*Drag*VICE

ALYSSA EDWARDS (*RuPaul's Drag Race*, Season 5, Episode 7, "RuPaul Roast")

"Don't get bitter, just get better." [IR20]

As long as you keep slaying forward, you'll always be in the momentum of your dreams.

RUPAUL

"When you become the image of your own imagination, it's the most powerful thing you could ever do." [IR4]

This is EXACTLY what slaying is—expressing YOURSELF to the fullest degree! That's TRUE power, babe!

COCO BARDOT

"Take a moment every day to lip sync. Do it in your car, your room, anywhere you can take 5 mins to just let loose and feel yourself. Give yourself a moment to be a Diva version of yourself." [PC1]

You gotta believe it and be it first before anyone else will!

Be more DRAGWERK

Put your heart into it. Whenever you are doing something—posting on Instagram, cooking a meal, walking to the grocery store, making an entrance at a party—how can you put your whole heart into it?

Hint: Start with presence. Start with giving the thing you are doing your undivided, not-multitasking attention. Your heart lives in the present moment. And so does your slay. Do this every day for the remainder of the semesters and watch your life, heart, and dreams catch fire!

YOUR *Draguation*

Give yourself some applause, hunty! You just finished some **BIG, LIFE-ALTERING WORK!**

Here's a chance to gather your thoughts and review all the werk you've done this semester:

★ **Lesson #13:** You've ignited your spark and taken one action as a result of it.

★ **Lesson #14:** You've journaled about the royalty you *already are*.

★ **Lesson #15:** You've put your heart into at *least* one thing in Lesson #15 and... you've committed to doing it every day, as often as you remember.

Now we're gonna take that heart and make it **ICONIC!**

BECOMING ICONIC: LESSONS FROM THE LEGENDS

Here's Drag Secret #9 (which isn't really so secret):
WE, drag and non-drag folxs,
ALL want to be LEGENDARY!

We all want to be seen. Witnessed. *Remembered*. To leave a sparkling rainbow trail that says:

"I WAS HERE. I LIVED. AND I WAS SICKENING."

So, buckle up kats and kittens because this semester is one for the **AGES!**

LESSON 16

LEGENDARY VIBES

"Perfection on earth is really unattainable; however, your own personal best is more than enough. Just keep nurturing your thoughts and your craft."

The Legendary Tommie Ross [PC3]

Awestruck. Magic. Transfixed. That's *exactly* how all of us feel when a legendary drag artist takes the stage. The whole room floods with anticipation and a silence and hush falls over the audience. The excitement of being in the presence of greatness is palpable. All the host has to do is announce the artist's name and **BAM!** There's a line out the club doors to tip them.

THAT is pure legendary vibes and status. And the same qualities that make a legend in the world of drag are the ones that can make you a legend in any other art form, business, or arena. They are:

Heart (we covered that in Lesson #15) ★ Attention ★ Commitment ★ A never-ending devotion to your craft

Being legendary is not something any one of us can teach. It's something that you will have to come to know one-on-one yourself. It's a long road and success is not guaranteed, but what you will discover about yourself, your art, and your capability makes it all worthwhile.

Being legendary can only be learned (and earned) through the pursuit of excellence.

Be more DRAGWERK

Even though you can't bestow authentic legendary status on yourself, you can still act that way. You can still be intentional about calling those kinds of legendary vibes to you.

Start by being intentional about your magic. Grab your journal and answer the following prompts:

★ How can I bring more magic wherever I go?

★ How can I leave a lasting impression?

★ How can I commit myself more deeply to my craft?

Drag VICE

ALYSSA EDWARDS

"Just follow the yellow brick road and know that [it] is your yellow brick road, and there is an Oz, and you're gonna get to obstacles, and it's important not to give up, to find a way to maneuver around or over." (PC5)

The legend is built along the journey to your Oz. You have to trust the journey.

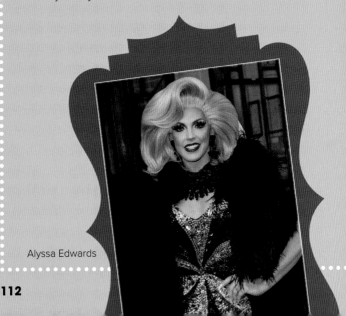

Alyssa Edwards

JENNA SKYY

"Becoming a legend isn't something you can chase. It's something that finds you. And the legends that I've worked among, just suddenly were legends one day—even when they talk about it. Sometimes they even joke [about it].

I was letting [Tommie Ross] in the back door of the Rose Room one time and someone was driving by and they said, 'OOOO! You're The Legendary Tommie Ross!' And she looked at me and said, 'See, Jenna! I'M A LEGEND!' [*Jenna laughs*]. And she has a wink and a smile about it. You know she doesn't carry herself like, I'M legendary. She's very humble about that. That honor has been given to her because of who she is as an entertainer." [PC1]

Keep putting your heart into everything. Keep slaying. Be intentional about everything you do and your legendary status will find you!

LESSON 17

BREAK THE MOLD

"Becoming a drag king has changed me because the way I perform my gender is entirely up to me... It's about realizing there are options to walk or dance in a different way, and that I can do whatever it is that I want to do."

Maxxx Pleasure [IR21]

All legendary and iconic drag artists are constantly trying to one-up themselves. They are constantly challenging themselves to grow and go where no other drag artist has gone before. They are always trying, and therefore actually managing, to break through new frontiers.

RuPaul broke the mold of what drag was and expanded it to whatever he wanted it to be—a record deal, an Emmy-award-winning show, and now a drag empire. Landon Cider and Tenderoni broke the mold of **ONLY** drag queens winning made-for-TV drag pageants. The Boulet Brothers broke the mainstream RuPaul narrative of what drag is when they introduced *Dragula* to the world. Fauxnique did it when she was

RuPaul

the first AFAB queen to win Miss Trannyshack. The list goes on and on.

The gold to glean here is this:

Becoming iconic in your life and industry always comes down to breaking down whatever pre-established molds, boxes, labels, or containers the overculture wants to keep you/me/us in. And to looking sickening while you do it!

*Drag*VICE

EDDIE BROADWAY

"Don't be afraid to challenge yourself. Everyone gets nervous, second guesses, and feels like they'll 'never get there,' but if you are truly coming up with new ways to inspire your art, you'll feel accomplished. It's not about how many crowns are on your head or recognition, it's about being better than you were the day before. Don't be afraid to break the mold. Don't be afraid to take risks." [PC2]

In other words, keep chopping away at your dreams. YOU WILL GET THERE.

CHANEL LAMASTERS

"Never place limits on your personal development. Always welcome the opportunity to learn something new, try something new, and to goal yourself above normalcy. Don't allow yourself to be comfortable." [PC2]

In other words, how much further and farther can you GROW? Whatever you answer, that's how you break your OWN mold!

Be more DRAGWERK

Think about the industry your dream is in. In what ways has it *always* been done? And what are some of the ways you could shake it up? Make a list of all the unique, heart-filled slayage that you can bring to the table. Pick one thing off your list and commit to doing it **THIS WEEK!**

EVOLVE

"Lately, people identify me with this very blank white face and really graphic eye. But everything evolves. Every time I come out, I take it as almost like a studio practice. Every time I'm out, I try to construct based on what I'm interested in at the time, and I feel it as a continuum. I'm constantly inspired and that's what's so amazing about drag. It's a constant flux—both creation and destruction."

Untitled Queen [IR22]

Here's Drag Secret #10:

Legends know when to reinvent and evolve. Madonna is the mother of reinvention. So is RuPaul. In order to have a lasting career in any industry, you are going to have to learn to evolve with the times, culture, technology, and pace of the world.

Drag has evolved tremendously over the past 20 years—and it will continue to do so forever. Chances are that whatever field your dreams are in has evolved drastically too. And if you want to become the stuff that legends are made of, you're going to have to keep growing. Keeping pushing forward outside both your comfort zone and your knowledge zone.

You have to be ever-evolving like every other artist, art form, being on this planet, and the universe. The big question is, are you *willing* to?

Drag VICE

LAYLA LARUE

"Live each day with a purpose. Take one day at a time and know that in life, it's okay to make mistakes. The lesson to be learned is to **NOT** repeat the same mistakes." [PC1]

This is also how you invite more evolution: by living from the lessons of your learning.

RUPAUL

"To win at life and to win in this competition, you have to be willing to die a thousand deaths and be reborn a thousand times." [IR23]

Evolution is a constant dance between death and rebirth. Something has to be surrendered (die) for your next phase to be ushered in.

AURORA SEXTON

"You can use your [life] experiences as a self-destructive tool or you can use them to build yourself up and become a better person. And for a time, I did let them destroy me. And I wasn't happy and took that out on the people around me... I think when you start to deal with those demons in your past, you can start to fully comprehend who you are as a person, and what you believe, and once you get to that really good solid center of who you are, that's when you really have the ability to start making change in the world for other people." (PC5)

Part of my legacy is to change the world. And while that might not be front and center for you, it's a beautiful and much-needed by-product of you going after and achieving your dreams.

Aurora Sexton

Be more DRAGWERK

Whether it's music, art, having a podcast, or starting a business, take a moment to look at the genre and field of your dreams and answer the following questions:

★ Where and how did it start? And what has it evolved into?

★ How have the major players in your field evolved with the changing times?

Pick one of those folxs and make them a study of what (and what not!) to do. Or use the proof person you chose back in Lesson #10.

What you're doing here is creating a blueprint for yourself of *how* you can evolve (with your own flawless variations, of course) when the time comes. 'Cause it's coming for all of us, hunties!

YOUR *Draguation*

Congrats, royal everythings! Most folxs won't even start. But even fewer folxs are committed to finishing whatever they do start. By completing this second-to-last semester, you are now in the elite top 5% of your class! Check off all the Dragwerk you've completed that helped get you there:

★ **Lesson #16:** You've journaled through the legendary prompts.

★ **Lesson #17:** You've created the list of slayage, disruption, and mold-breaking that you can bring to your industry.

★ **Lesson #18:** You've begun your evolution study, either of your industry or of a person within it.

The time has come, young draglings, to enter your **LAST** semester. It's time to bring the house **DOOOWN!**

LEAVING A LEGACY: LESSONS FROM A LIFE

Alright hunties, this is our *final* semester.

And since it's your very last one, this semester is all about you—the soon-to-be graduate—and me, your Head Dragmistrexx, getting together for a one-on-one kiki about how everything you have learned thus far can culminate, rather unexpectedly, into the legacy that is **YOUR LIFE**. And because your last semester is more of an independent life study, there will be no dragvice or individual *Be More Dragwerk*.

Instead, what you'll find at the end of the last two lessons is your final exam—the exam that covers everything, from where you started to how you're doing, where you're going, and what you are rising into.

Your final exam is life werk—the ongoing sickening work of your life. It's feelings werk. It's heart werk. It's the werk that legends, qweens, kings, and all royalty are made of. And it's the werk that will catapult you into your own legacy too.

MAGIC AND MANIFESTING ARE REAL

"Why be a Star when you can be a motherfucking galaxy?"

Brandi Amara Skyy [Self]

I've always said that I "willed" Miss Diva USofA into existence. Why? Because I did.

Six years prior to the system's existence, I was doing the work. I was practicing. I was honing my craft. I was studying and apprenticing drag queens. I was choreographing for, dancing with, and understudying drag legends. And in doing so, unbeknownst to me, I was solidifying my own legacy.

I'll never forget the day I received the news that the one pageant system I had always wanted to be a part of was beginning an AFAB pageant. I had just met Raja Gemini on a Sunday Funday with my drag mother and friends when I got the phone call from an Oklahoma drag king. As he spoke, I could feel my entire body coming alive. And even though I had just learned about the pageant that day, I knew in my heart, gut, and soul that I was ready.

I was ready because I had already been living, performing, and acting AS IF my dream to become a bona fide drag pageant queen was already available. I went and studied the pageants. I knew my drag history and researched whatever I didn't know. I told **EVERYONE** I met that I was gonna be a drag pageant queen—**EVEN THOUGH FOLXS LAUGHED IN MY FACE AND TOLD ME IT WAS IMPOSSIBLE** because I was born an AFAB girl.

So, when the pageant system finally caught up with my dreams and actions, it was fated. I won the first ever Miss USofA Diva prelim ever to exist in Oklahoma in 2013. And then the first national pageant in 2014. And now, not only can I say that I won, but I am also part of drag's history. All because I operated as if the thing that I wanted already existed—even though it didn't.

This is what I mean when I tell my clients, friends, family, and now you that anything is possible. This is what I mean when I say: "Magic and manifest the F*** out of your life."

You want my advice on creating and living a life that forges a legacy? It's this:

KEEP CHURNING AT THE THINGS THAT MAKE YOUR SOUL BURST WITH ALIVENESS AND THE WORLD WILL CATCH UP.

And when it does, you'll be ready.

LIVE YOUR LEGACY

"Everything is connected. You are already a work of art. Now your job is to curate it. To curate yourself and bring the art of you into a story that's coherent enough, so you can tell and express it... Connect your dots. Become the art. Make everything intentional. And live from your gut."

Brandi Amara Skyy [PC2]

The most potent words spoken to me after I won Miss Diva USofA came in a phone call from Ivory Onyx, Mr USofA MI 2013. Somewhere in our 45-minute conversation, he asked me a question that has forever haunted me:

"What do you want your legacy to be?"

But at the time I didn't really hear what he was asking, because when he finished all I could think was, "I'm already living it." And while this was true at that moment, what I missed was the bigger

picture. A picture that I only fully understood many years later: the difference between history and legacy.

My USofA Diva win was living and breathing history in the making—but making history does not automatically create a legacy. The real question he was asking me at the time was, *How do you want to be remembered?* As my adventures in drag have evolved and changed, the question has since morphed into something even more profound for me than that.

HOW WILL I LIVE THE LEGACY I WANT TO LEAVE BEHIND, NOW?

And while being legendary may be something that you can't gift yourself, your legacy IS.

Your legacy is a prestige that only you can bestow on yourself by paying radical attention to what you are putting into it RIGHT NOW. Are you acting in ways that are becoming of the legacy you want to build? Are you approaching your life and dreams as the legend you hope to be some day? Are you chasing your dreams in the manner in which you want to achieve them and with the right energy and frequency? Are you living in alignment with what you value? Are your dreams congruent with your life? Are you wanting to be sickening for the sake of being sickening? Or is there something more to it?

HOW DO WE CREATE A LIFE THAT OUTLIVES US?

Whatever your answer, your legacy can only be found swimming in there.

"In any field or any interest you pursue... you have to really know what it is you're trying to offer and present. You know my legacy, I never wanted to be the most beautiful or the most talented. My legacy was more about, 'Can I be reliable and accountable and what can I give back?' Can I give something through my performance? Or something backstage? Or just not being a nasty bitch in the background and tearing everyone down to try to pedestal myself? Or not being toxic? Or maybe more positive?

What am I presenting? And I want people to know that, as an entertainer, I'm always going to exceed expectations, that I'm going to be professional, that I'm going to be entertaining, that I'm going to be reliable. And I'm somebody that when I'm around, I'm good for the energy, for the environment, and for the audience. That I'm engaging and approachable.

Those are things that I wanted from my legacy. I wanted people to enjoy my company and look forward to my company and then also enjoy what I'm doing in the show."

Jenna Skyy [PC1]

What legacy do YOU want to leave behind?

That's it, hunties!

Your answer—and more importantly *how you live it*—IS your final exam.

Go out and be proof of what is possible when you believe—first in yourself, then in your talents and skills, and finally in your magic.

Go out and slay **MULTIPLE** dreams.

Go out and *be* the dream and reason someone else wakes up believing that nothing is impossible.

Go out and live your life to the fullest.

What you do in your life and with your life is the only exam that truly matters.

And only **YOU** can say if you pass or fail.

COMMENCEMENT CEREMONY

**eh hem* taps mic*

Cats, kittens, and squirrels, as your Head Dragmistrexx it is my divine honor to introduce you to the individual you have all selected to be the class speaker.

Drum roll please...

SURPRISE!! IT'S YOU!

YOU are this book's Valedictorian (or should we say Dragadictorian?!?).

And now it's time for you to share **YOUR** advice with **US!**

What have you learned and uncovered on this grand adventure of your dreams?

Head over to Instagram and use #bemoredrag to share all the tea you learned with me!

And remember:

Your dreams matter.

Your art matters.

And **YOU** matter.

NOW GO FORTH AND SLAY!

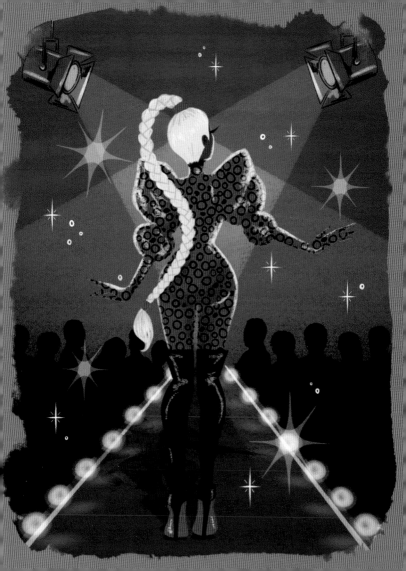

GLOSSARY OF DRAG TERMS

AFAB Assigned female at birth.

AMAB Assigned male at birth.

Baking Used to describe the time we allow for our foundation and highlighter to set into our drag mug (*aka* **bake**).

Death drop A sickening dance move where the drag artist surprises the audience by purposely dropping to the floor on their back, one leg extended, and the other bent.

Drag artist An all-inclusive and gender-neutral term (and my term of choice), referring to all dragsters who prefer not to gender-label their art.

Drag King An AFAB, cis-woman, or transman who drags as male. In terms of popularity, drag kings are a far-away second to the drag queen. A new wave of femme kings is emerging that blurs the gender lines even more—and I am here for it!

Drag mug A drag artist's signature makeup face (either complete or underway).

Drag Queen An AMAB, cis-man, or transwoman who drags as a female. The most popular and mainstream of all the drag artists. Drag queen can also be a generic term for all drag artists (in the same way some people would use the word 'coke' to describe all sodas such as Coca-Cola, Pepsi, etc).

Face When a drag artist's mug looks so damn good that they are serving FACE to the GAWDS!

Female Drag Queen An all-inclusive umbrella term for cis-women or AFAB women who do drag. Other terms include AFAB Queen, Diva, Femme Queen, Bio Queen, Lady Queen, and Faux Queen.

Female Impersonator As above, but their drag specialty is the impersonation of a particular singer, star, or celebrity. Female impersonation—as in, impersonating a female in style, manner, and dress—was also one of drag's first and main definitions.

Kiki A cute little get-together and talk with your favorite friends!

Look Queen/King/Artist A drag artist who may not necessarily perform, but who serves up a sickening drag look anyway. A drag artist who serves serious mug and face.

Male Impersonator or **Entertainer** This term is used to describe an AMAB or cis-man, who also drags as male. Like the faux queen, he could be called a faux king. A good example of this form of drag is seen in the Mr. Gay USofA pageant system.

Mug Short for drag mug (see above).

Sickening When something is just too dope to handle. The person, place, or thing is just so extra and extravagant that it's reached the level of sickening!

Slay To bring an audience, people, a crowd to their knees (actually, more like to the floor) with our fierceness.

Tea Tell all the gossip! Spill the tea! When an artist tells someone everything they know, usually with a side of shade.

Tipping When a drag artist isn't booked at the show, but they still show up in full drag looking flawless, just to walk around and be seen.

Wheelhouse Your orbit or comfort zone—your area of interest, knowledge, or experience.

REAL-LIFE RESOURCES

Because life is a rather long journey, below is a list of resources that may serve you as you continue with your real-world graduate studies!

Here are links to resources mentioned throughout the semesters:

Your Dreams Are Not Impossible

Surprise! Listen up, dream snatchers! As a very special graduation gift, I would like to give you access to my best-selling course, *Your Dreams Are Not Impossible*. All you need to do to receive your gift is head over to **www.wokemagic.com/bemoredrag**, fill out the form, and hit submit. (Heads up, hunty. You will be asked to share a few words from your final exam, just to make sure you've put in the WERK!)

Jinkx Monsoon "Water Off a Duck's Back"

https://youtu.be/_EPCPAx7h6k

And here are some more resources:

Brandi Amara Skyy, *How to Be a Drag Queen*
(Independently published, 2019)

Especially if you have big, bold drag dreams. And even if you don't, I've been told this book of mine is great for artists and creatives from all walks of life! HTBDQ is the book that started it all—and it can help you slay your drag game!

Brandi Amara Skyy, *The Little Book of Drag*
(Dog 'n' Bone Books, 2022)

If you love drag, then I highly recommend picking up my first book, *The Little Book of Drag.* This serves up all the drag tea in an inclusive, no-drag-artist-left-behind, history-making way.

Be More Drag Limited Podcast

Created EXCLUSIVELY as a companion to this book, aka The Drag School of Dreams. This limited series podcast dives even deeper into conversations with some of my favorite drag artists about what it takes to truly live your dreams. Check it out at: www.wokemagic.com/bemoredrag.

SOURCES

The majority of the advice found throughout this book was sourced from my personal archives after decades of talking to and creating within the drag community.

Personal correspondence and archival credits are as follows:
PC = Stands for Personal Correspondence
PC1 2022 Interviews and Survey
PC2 *How To Be A Drag Queen* (book by Brandi Amara Skyy)
PC3 Personal email exchange
PC4 *Gag* Magazine article from 2014 (I was the founder and editrix)
PC5 The Drag Show Podcast

Other supporting advice found and credited as follows:
IR = Stands for Independent Resource
IR1 https://www.anothermanmag.com/life-culture/10308/aquaria-s-top-tips-for-aspiring-drag-queens-interview-2018
IR2 https://www.backstage.com/magazine/article/bob-the-drag-queen-drag-race-advice-podcast-71990/
IR3 https://www.yourtango.com/2017303796/10-sassy-quotes-queens-rupauls-drag-race-season-nine
IR4 https://kidadl.com/quotes/best-drag-queen-quotes-to-help-you-feel-fabulous
IR5 https://www.gaytimes.co.uk/culture/exclusive-brooke-lynn-hytes-on-why-it-will-take-risks-to-win-canadas-drag-race/
IR6 Lyrics from RuPaul's song Sissy That Walk https://www.youtube.com/watch?v=M4d20TyzIv0

IR7 https://twitter.com/rupaulsdragrace/status/340534584120852481?lang=en

IR8 Goodreads quote: https://www.goodreads.com/quotes/717044-if-you-have-goals-and-the-stick-with-it-ness-to-make-things

IR9 https://www.bravotv.com/blogs/meet-sasha-velour-from-rupauls-drag-race

IR10 https://indymaven.com/articles/beauty-tips-drag-queens-pageants/

IR11 https://www.papier.com/us/thefold/articles/a-note-to-my-younger-self-amrou-al-kadhi

IR12 https://twitter.com/xosonique/status/1426203016202489859

IR13 https://www.wmagazine.com/story/rupaul-inspiring-quotes-rupauls-drag-race

IR14 https://www.youtube.com/watch?v=Lpqv8lWttCk

IR15 https://thebuzzmag.ca/2017/10/scarlett-bobo-drag-family-taking-risks/

IR16 https://twitter.com/rupaul/status/42738850195439617?lang=en

IR17 https://variety.com/2022/awards/news/rupauls-drag-race-willow-pill-jinx-monsoon-1235340337/

IR18 https://www.happiness.com/magazine/inspiration-spirituality/life-lessons-rupaul-biggest-drag-queen-world/

IR19 https://www.overallmotivation.com/quotes/willam-belli-quotes/

IR20 https://twitter.com/rupaulsdragrace/status/737668745372553218?lang=en

IR21 https://awomensthing.org/blog/drag-king-lee-valone-velour-johnny-cash/

IR22 https://www.thrillist.com/drink/nation/untitled-queen-interview-evolution-of-brooklyn-drag

IR23 https://everydaypower.com/rupaul-quotes/
IR24 https://www.women.com/ashleylocke/lists/bob-the-drag-queen-quotes-050119

"Everything works out in the end, and if it's not working out, it's not the end."

Bob the Drag Queen (IR24)

PICTURE CREDITS

Index

ACKNOWLEDGMENTS

Thank you to every single person who read (or has yet to read!) my first book, *The Little Book of Drag*. Y'all made this second one possible. To *mi familia*—blood, extended, and chosen: this art is always for and because of you. Mom, Dad, thank you for never NOT believing in me and my ability to achieve my dreams. Marissa and Judy, thank you for supporting and welcoming me into your family. To Dana—I will NEVER stop thanking you for your ongoing support, love, and friendship. You have made so many of my dreams possible. To Penny, my amazing publisher rep, a deep bow of gratitude for the opportunity to write a book that helps folxs not only grow and glow in their magic but shows them how to be fierce, fabulous, and have fun while doing it! To my wife, C. All of this, everything I do, is always for you. For us. We are in this together, forever. I love you for lifetimes.